# Love you, Dad

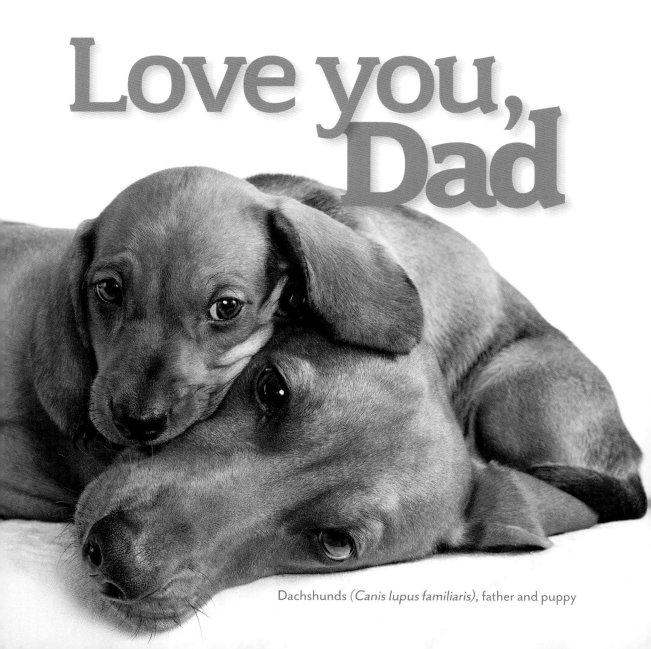

Dachshunds (*Canis lupus familiaris*), father and puppy

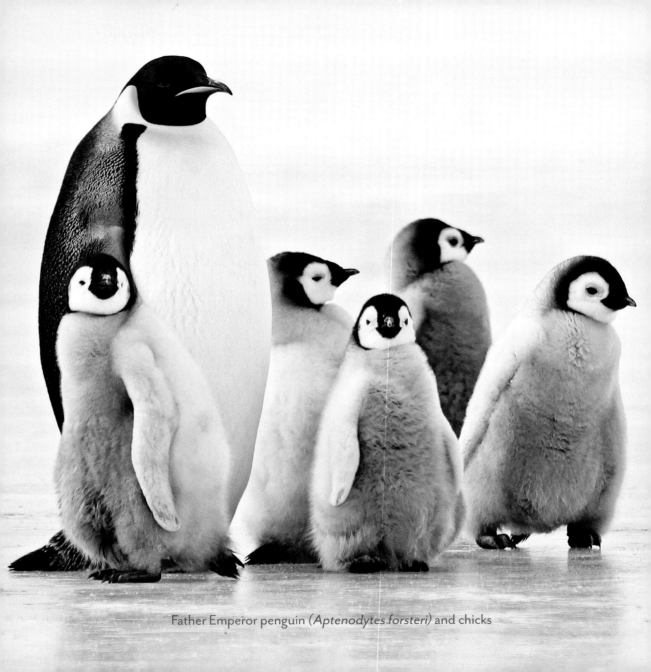

Father Emperor penguin (*Aptenodytes forsteri*) and chicks

# Love you, Dad

## Dad

a book of
**thanks**

Melina Gerosa
Bellows

**NATIONAL GEOGRAPHIC**

WASHINGTON, D.C.

## Published by the National Geographic Society

Copyright © 2012 National Geographic Society. All rights reserved. Reproduction of the whole or any part of the contents without written permission from the publisher is prohibited.

ISBN: 978-1-4262-0923-9

The National Geographic Society is one of the world's largest nonprofit scientific and educational organizations. Founded in 1888 to "increase and diffuse geographic knowledge," the Society's mission is to inspire people to care about the planet. It reaches more than 400 million people worldwide each month through its official journal, *National Geographic,* and other magazines; National Geographic Channel; television documentaries; music; radio; films; books; DVDs; maps; exhibitions; live events; school publishing programs; interactive media; and merchandise. National Geographic has funded more than 9,600 scientific research, conservation and exploration projects and supports an education program promoting geographic literacy.

For more information, visit www.nationalgeographic.com.

National Geographic Society
1145 17th Street N.W.
Washington, D.C. 20036-4688 U.S.A.

For information about special discounts for bulk purchases, please contact

National Geographic Books Special Sales: ngspecsales@ngs.org

For rights or permissions inquiries, please contact National Geographic Books

Subsidiary Rights: ngbookrights@ngs.org

Interior design by Melissa Farris and Jonathan Halling

Printed in the United States of America

12/WOR/2

Yup, Dad.
Thanks for everything.

# introduction

Every daughter has a "dad story"—a cherished tale that encapsulates her relationship with the man who helped bring her into the world. Mine, as it happens, involves a dog bite. My kids love this tale, and my father, who came to my rescue, loves to tell it.

It's right before Father's Day. We're all lounging by the pool deck, and Grandpa's just getting to the good part. My kids, five-year-old Mackenzie and seven-year-old Chase, are riveted. Mouths agape, they resemble two frozen statues as they stand before him. All that moves is the pool water dripping from their bathing suits.

"Your mother was right around your age," he's saying. "And the first thing we heard was the sound of her crying: *'Waa! Waa! Waa!'*"

Mackenzie looks relieved. The story is exactly the same as last time.

"But then we see her, and her eye was hanging out *like this*," he says holding his hand in front of his cheekbone like a catcher's mitt.

"Was there a lot of blood?" asks Chase.

"Yes!" Grandpa says enthusiastically. "So much we couldn't see her face."

Mackenzie nods, knowingly.

"Was the eye *out* out," asks Chase, always double-checking, "or just *sort of* out?"

Grandpa cocks his head and thinks a minute. This is the grand finale, and he knows it.

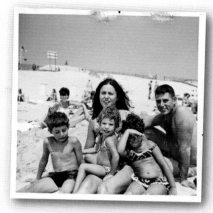

*Day at the beach, circa 1970. Suzi and Carl Gerosa with kids C. J., Melina, and Jennifer.*

"Dangling!" he finally declares.

*"Ewwwww,"* they both say in unison and, completely sated, jump into the pool.

They already know that the story has a happy ending: Dad races his daughter to the E.R., just in time. Sixty-seven stitches and a lot of luck later, their mom has 20/20 vision.

"Thanks, Dad," I say 40 years later. "For the eyeball."

We both laugh.

And everything else, I want to add. But I don't.

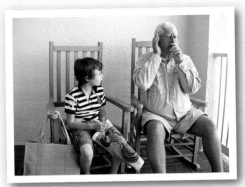

*Grandpa Carl regaling six-year-old Chase Bellows during a Florida vacation.*

My father isn't the touchy-feely type, given to expressing his emotions. But every time he tells this story, I realize how much he loves me. Reflecting on his unstoppable heroism and the knowledge that he's always been there for me, no matter what, I am flooded with love and gratitude—for how much I owe him, and how much he's shaped me over the years.

In my family as in so many others, we never put that stuff—the really important stuff—into words. We communicate it all through code. Humor is one way, and showing up for each other is another. We have always been a family of doers, rather than talkers.

The Dalai Lama once observed that the purpose of human life is to help one another. My dad taught me that lesson by example. One time, he patiently extracted 19 splinters from my leg. He's moved me in and out of more dorm rooms and apartments than I can count. He takes my house maintenance issues as seriously as his own. When he misses us, he'll call to breezily

announce, "Gotta drop off some stuff your mother bought you."
Then he'll get in the car for a ten-hour round-trip errand.

But the L word, we avoid. I remember the chilly November
morning when Dad called my dorm room to tell me my beloved
grandmother had passed away.

There was a moment of silence.

My heart lodged in my throat. "I love you," I managed to blurt.

"Yup," he replied and hung up the phone.

Embarrassed, I looked at the dead receiver in my hand and
realized I probably should have offered to come home and
change a lightbulb.

Yet I know I need to express these feelings, and he needs to
hear them. That's why Father's Day presents an annual chal-
lenge. Often, a card is not enough to express the love and
appreciation a father deserves.

So I turned to my animal friends, those rock stars of the
animal kingdom who capture the true spirit of fatherhood.
Perhaps they can help us articulate something we don't have
the words to say ourselves. For example, male sea horses give

birth. Male catfish carry marble-size eggs in their mouths for six weeks, surviving off their own body fat as they nurture their young. And, of course, there are Emperor penguins, who starve and freeze for two long months in order to protect the egg—balanced on their feet—that holds their baby chick. These animal fathers' selfless instincts—to care and protect, to love and nurture—helped inspire me to write this book.

It was those kinds of paternal impulses that helped me through a particularly rough patch a few years ago. My parents, who had been visiting me at my home in Washington, D.C., were about to begin their drive back to New York.

I was not in a good place. It was clear that my ten-year marriage was over, and I was terrified at the prospect of being a single mom while dealing with the demands of a full-time job.

When my father came to say goodbye, I couldn't help it: The dam broke, and I burst into tears. Since expressing emotion is far outside our family's comfort zone, I was expecting a glib retort to break the tension, or perhaps a platitude before

he dashed to the safety of the car.

Instead, my father sat down beside me. He didn't say anything to try to make me feel better, because he knew that nothing he could say would. I cried and cried, and he simply stayed with me, allowing the painful dignity of the truth to begin the healing process. It was an incredible act of bravery.

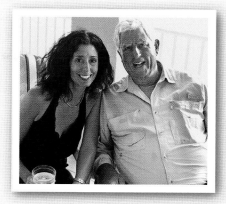

*Melina and father Carl,*
*present day*

When I finished crying, he nodded and patted my hand.

We looked at each other.

"Yup," I told him.

Every child has their own way of expressing love for their father. I hope the book you hold in your hands—and the animal ambassadors in it—will help you do just that. In bestowing it, you'll be sending a simple but powerful message: "Thanks Dad, for everything. I love you."

## MELINA GEROSA BELLOWS

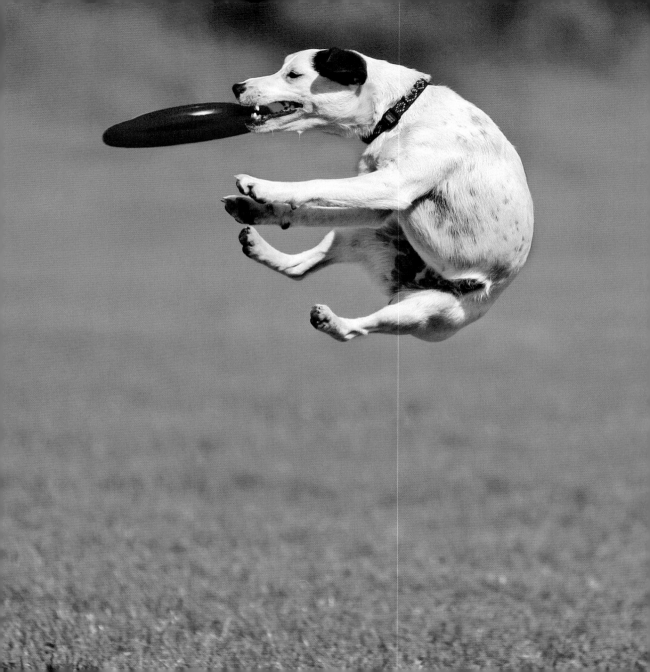

# Love you, Dad,
# for showing me how to
# **go for the gusto.**

Male domestic dogs (*Canis lupus familiaris*) who become fathers
are commonly referred to as studs.

# Love you, Dad,
## for teaching me to
### never sweet a bad hair day.

The fancy head feathers on Polish roosters (*Gallus gallus domesticus*)
may obscure their vision and even make them skittish.

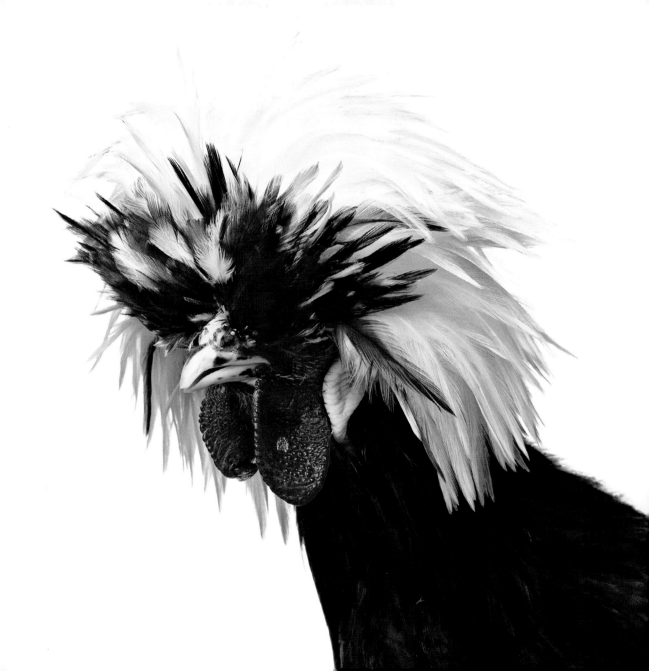

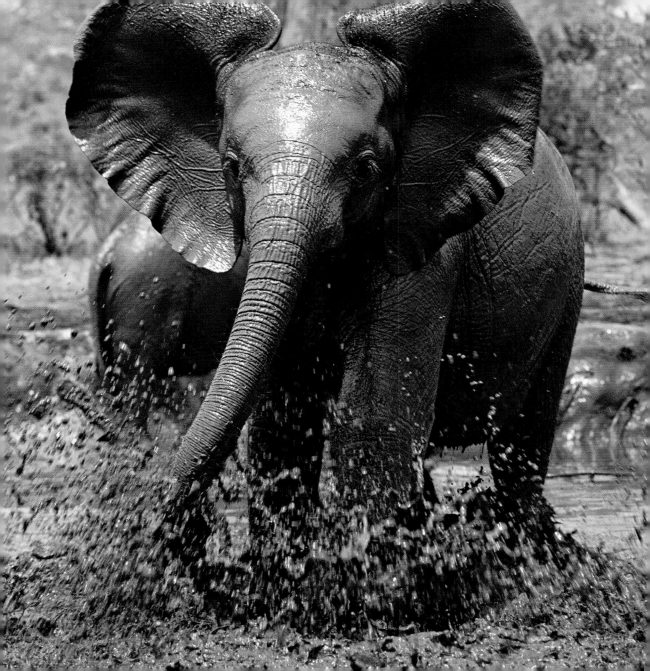

# Love you, Dad,
## for telling me that
# cleanliness can be overrated.

The largest male African elephants (*Loxodonta africana*) with the
biggest tusks are the most likely to become fathers.

# Love you, Dad,
for teaching me that **courage** is just **fear that's said its prayers.**

Newly hatched scarlet macaws (*Ara macao*) depend on their fathers to eat.
Dad feeds them by regurgitating liquefied food into their mouths.

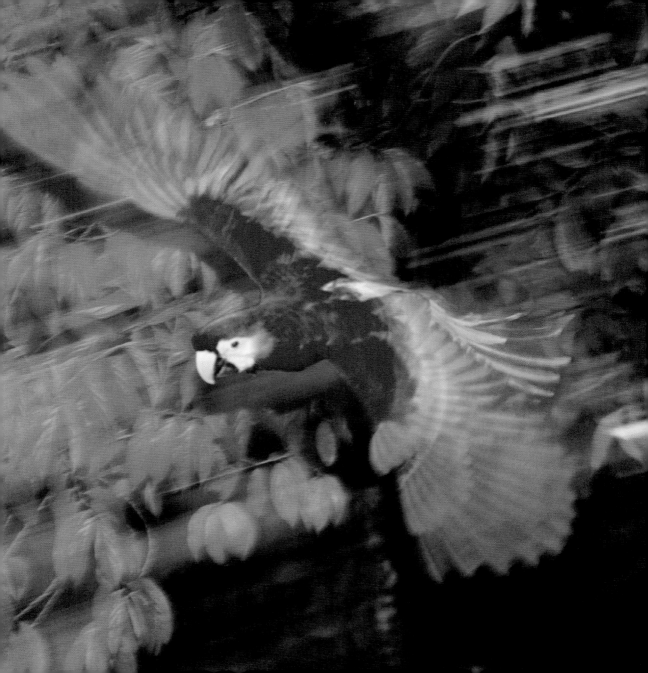

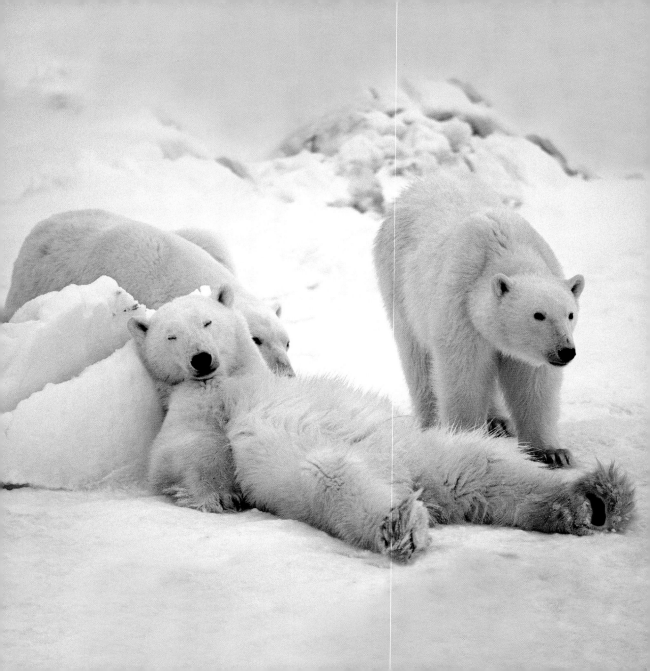

# Love you, Dad,
## for demonstrating the ideal way to **kick back and relax.**

An adult male polar bear (*Ursus maritimus*) can weigh up to 1,760 pounds and measure more than eight feet long from nose to tail.

Love you, Dad.
**Lipstick on a pig**
never did fool you.

In the wild, most female pigs and their young *(Sus scrofa)* live in large herds called
sounders, but mature male hogs typically live on their own.

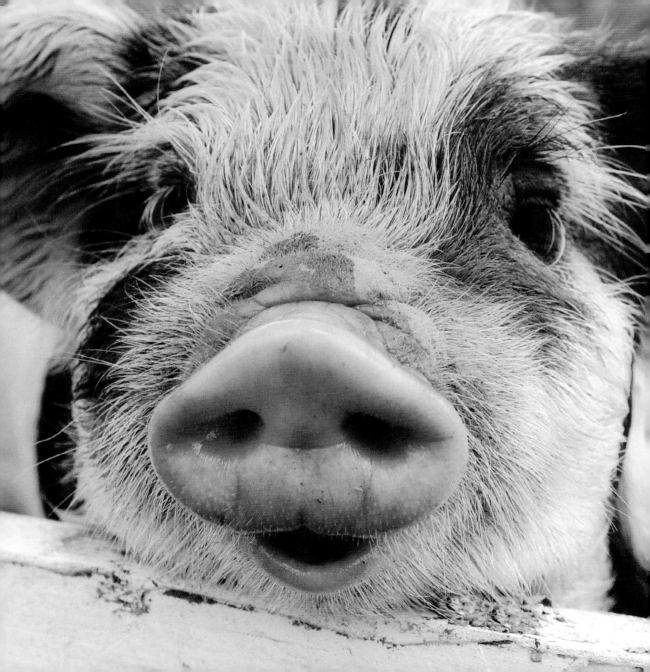

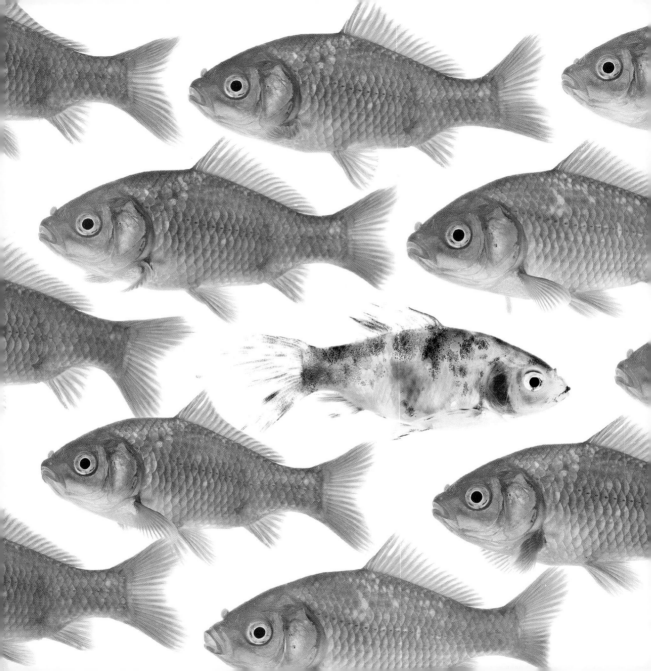

# Love you, Dad,
# for always letting me
# **do my thing.**

When male goldfish (*Carassius auratus auratus*) look for love, small bumps called tubercles develop on their heads and pectoral fins.

# Love you, Dad,
# for sometimes
# **looking the other way.**

As hatchlings, male veiled chameleons (*Chamaeleo calyptratus*) are pale green, but as they mature they may develop vibrant patterns of turquoise, yellow, orange, green, or black.

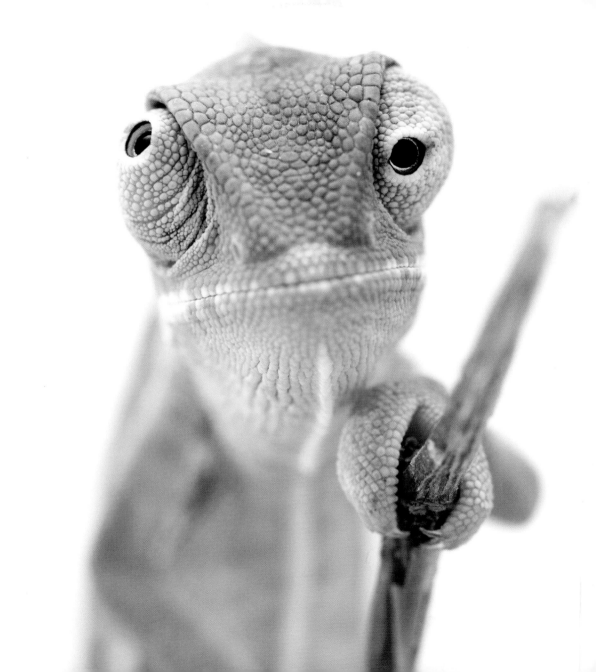

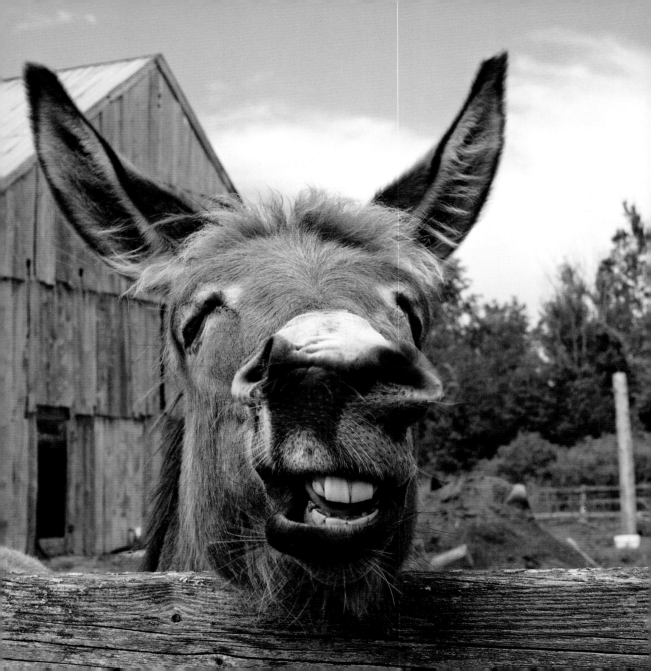

# Love you, Dad.
# Thanks for
# **laughing at my jokes.**

Male donkeys (*Equus africanus asinus*) are often called jacks.

# Love you, Dad,
## for helping me
### be as clever as you are.

Red foxes (*Vulpes vulpes*) work together to raise a family: Dad brings food to the den to feed Mom, who must stay in the den to care for the newborn kits.

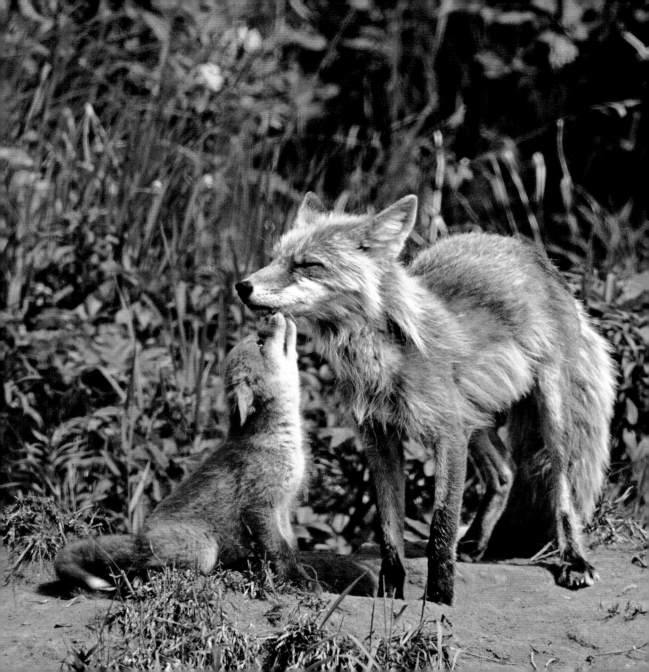

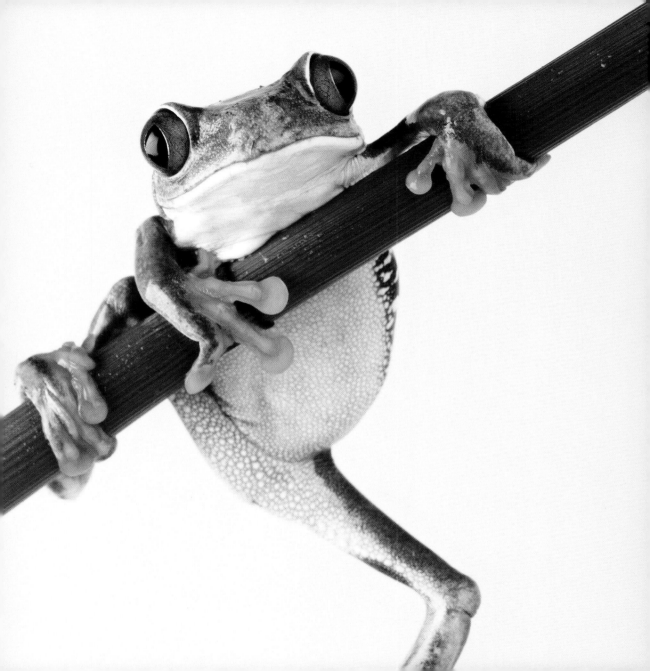

# Love you, Dad,
# for **always hanging in there.**

Male red-eyed tree frogs (*Agalychnis callidryas*) engage each other in loud croaking contests to establish dominance and attract females.

# Love you, Dad,
# for **lending an ear.**

When prairie dogs *(Cynomys ludovicianus)* grow up, they may strike out to find a new colony. Males are more likely to roam, especially during breeding season.

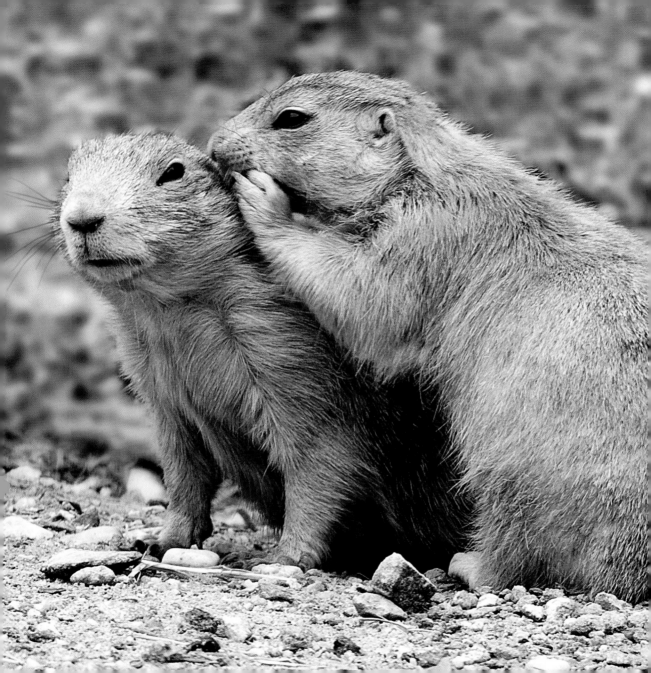

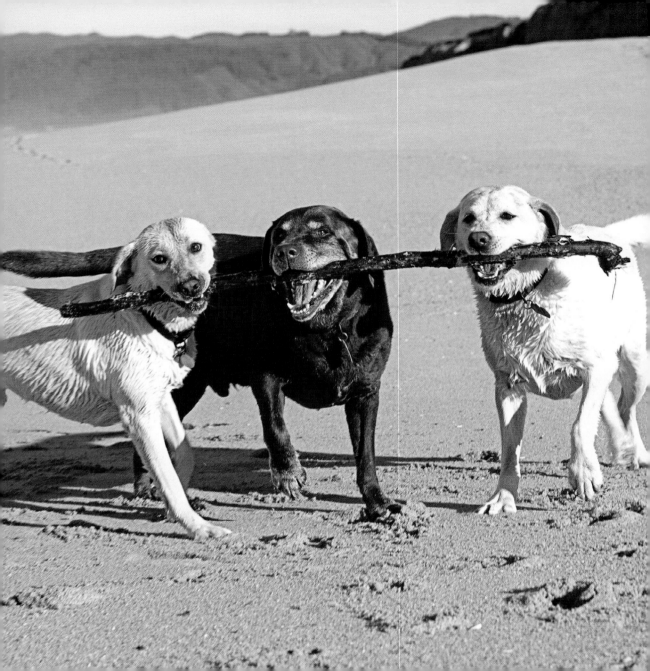

# Love you, Dad, for helping me **make new friends.**

In some feral packs of dogs (*Canis lupus familiaris*), males—be they fathers, uncles, or otherwise—help care for puppies.

# Love you, Dad,
# for the encouragement to
# **venture boldly forth.**

Dwelling in coral reefs, the male flame hawkfish (*Neocirrhitus armatus*)
often shares his space with two to seven female fish.

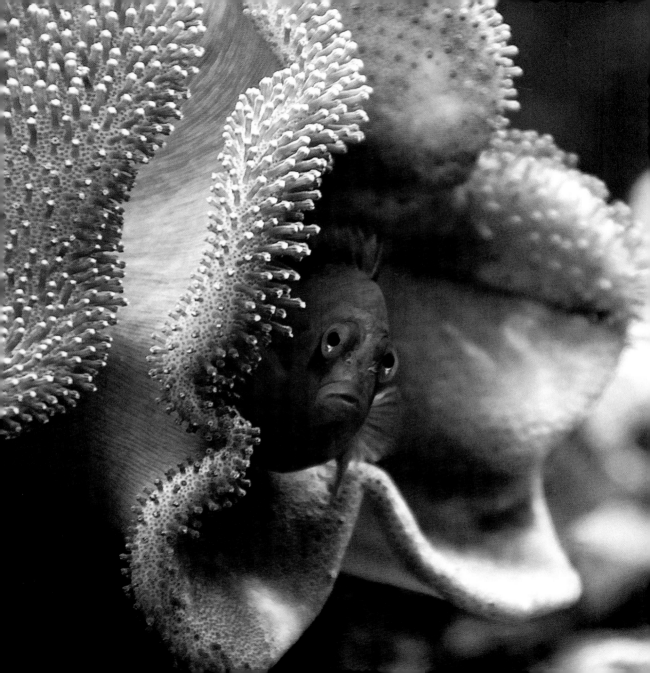

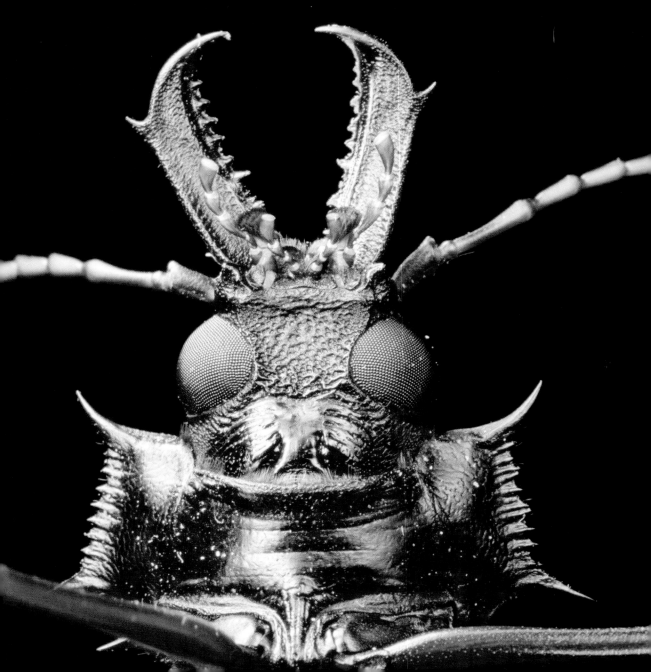

# Love you, Dad,
# for telling me
# **the best scary stories.**

When competing for mates, male longhorned beetles (*Macrodontia cervicornis*)
use their clawlike jaws to battle each other.

# Love you, Dad.
# Everyone says I'm
# **the spitting image** of you.

Male orangutans (*Pongo pygmaeus*) can live to be more than 55 years old.
At these advanced ages, an absence of bald spots is an indication of good health.

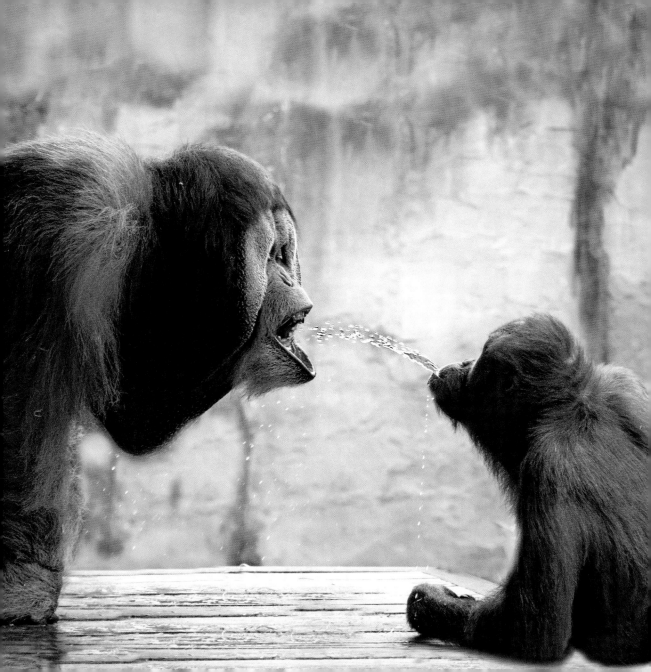

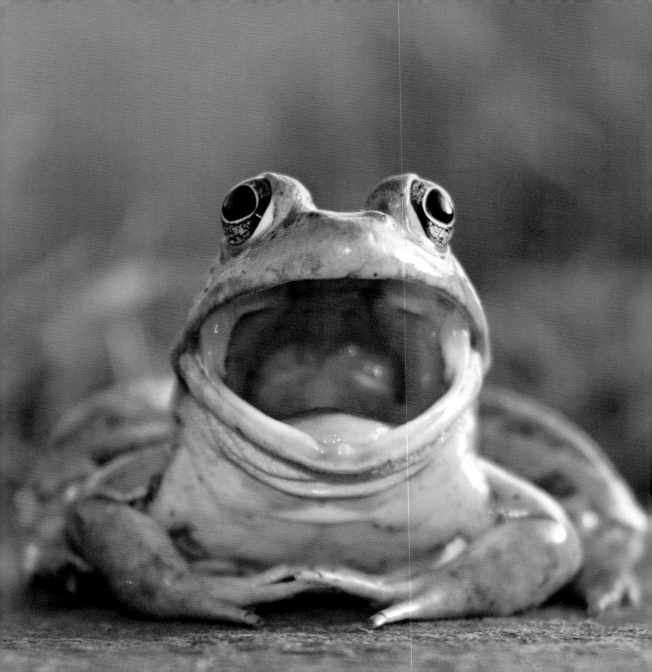

# Love you, Dad,
# for your **big belches.**

During breeding season, the throat of a male North American bullfrog
(*Rana catesbeiana*) turns yellow, while the female's stays white.

# Love you, Dad,
## for the many times you
## **lent me a hand.**

Male brown-throated three-toed sloths *(Bradypus variegatus)* are sought by females,
who loudly and shrilly screech to attract potential mates.

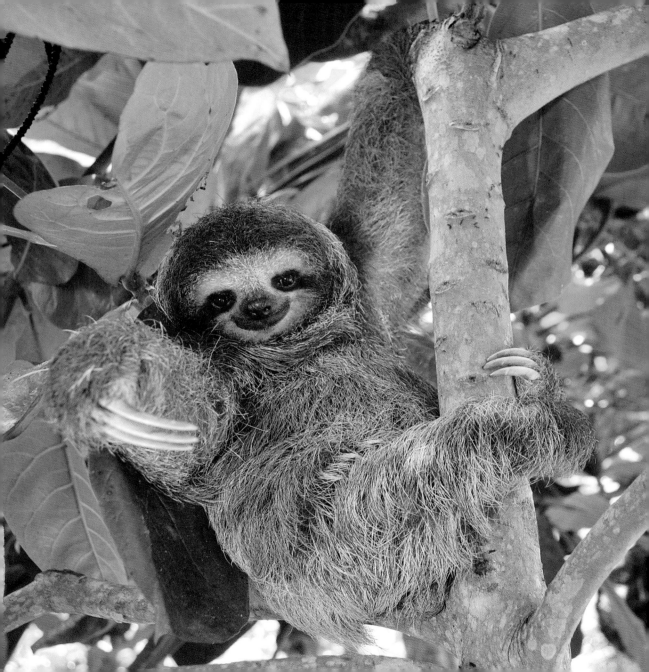

# Love you, Dad,
## for teaching me that some things
## are better left alone.

During their winter sleep, female skunks (*Mephitis mephitis*) typically share a den with other females and their young, but males tend to sleep alone.

# Love you, Dad,
## for teaching me
### right from wrong.

By the age of eight months, male cats (*Felis catus*)
are reproductively ready to become dads.

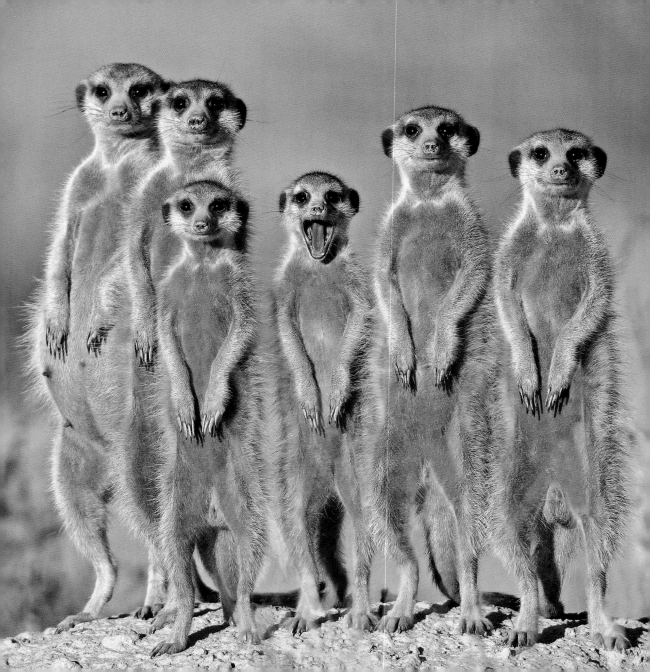

# Love you, Dad,
# for showing me how to
# **stand out in a crowd.**

In a meerkat mob, every member has a job to do. Father meerkats
(*Suricata suricatta*) contribute by protecting the young from intruders.

# Love you, Dad, for having a **bark** worse than your **bite.**

When facing off against a threat to the family unit, father gorillas (*Gorilla gorilla*) often beat their fists against their chests in a show of strength.

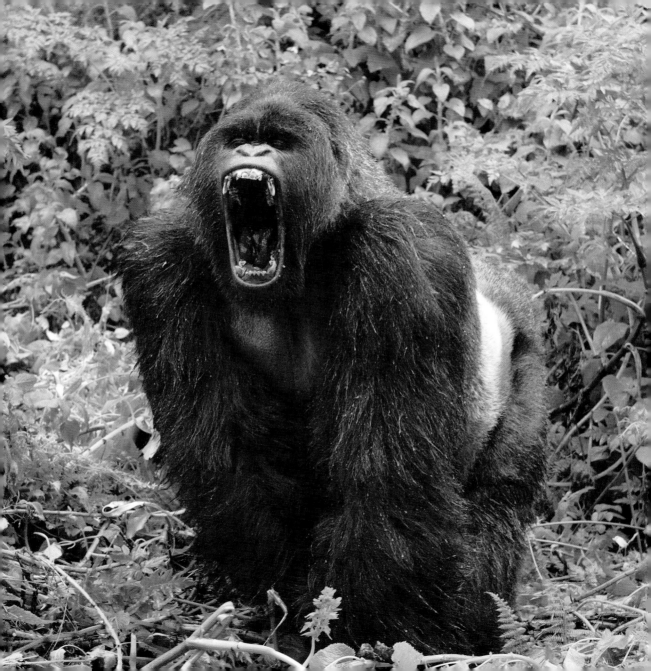

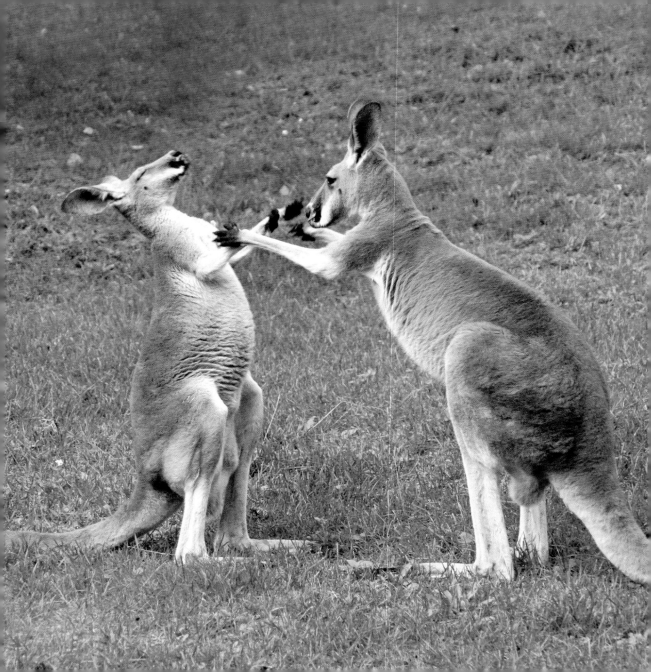

# Love you, Dad, for teaching me to **stand up for myself.**

To establish dominance, male eastern gray kangaroos
(*Macropus giganteus*) often "box" each other.

# Love you, Dad,
# for taking me
# along for the ride.

After fertilizing the female's eggs, a male jawfish (*Opistognathus muscatensis*) will gather them in his mouth and hold them until they hatch. During this time, he typically does not feed.

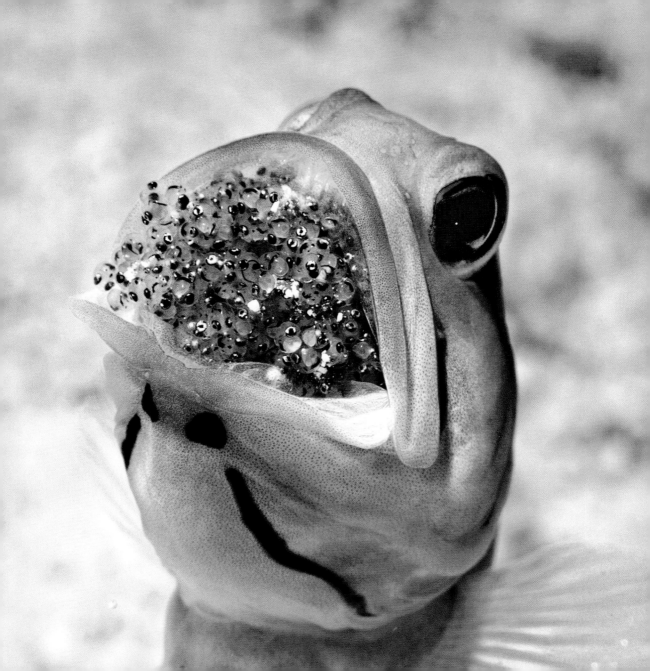

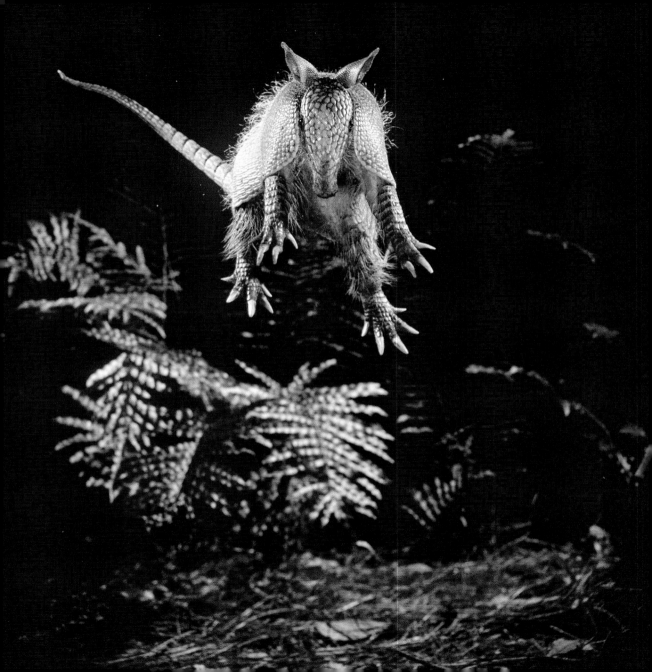

# Love you, Dad, **for understanding** my fear of the dark.

To the naked eye, there is little discernible difference between male and female nine-banded armadillos (*Dasypus novemcinctus*).

# Love you, Dad,
# for (occasionally) letting me
# **stuff my face.**

Defeating all other challengers is no guarantee of a mate for a male eastern chipmunk (*Tamias striatus*). A female may still reject him and chase him out of her burrow.

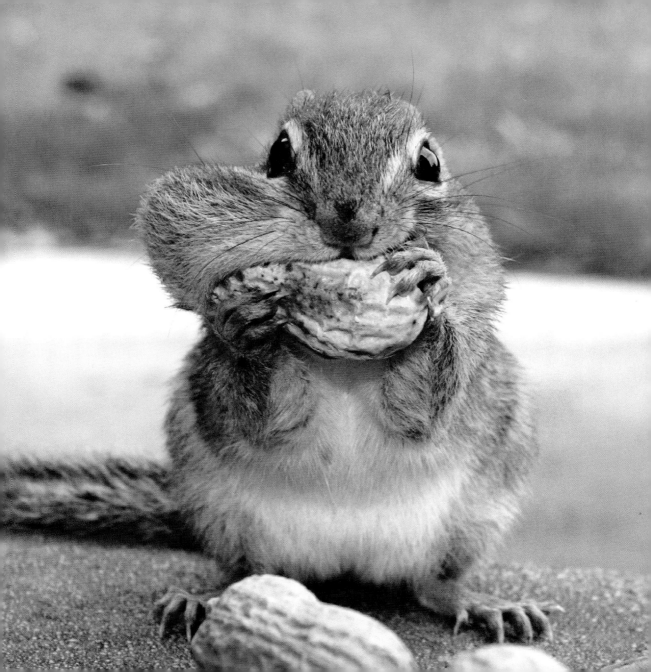

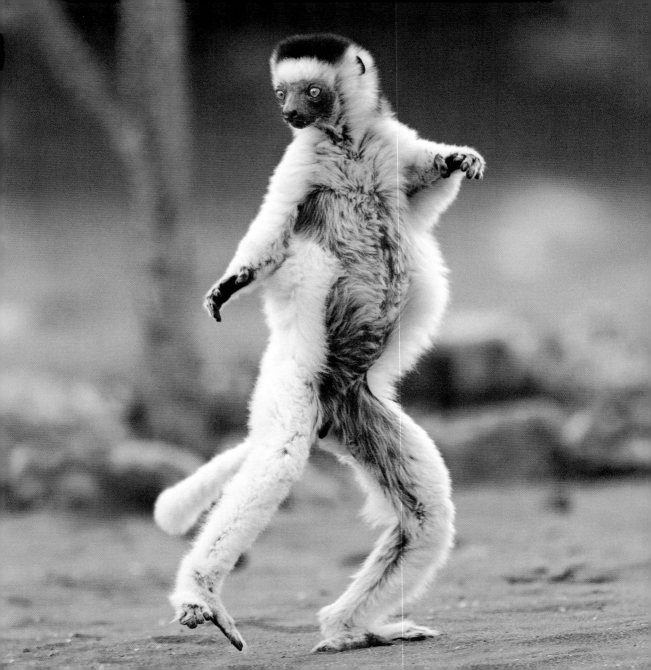

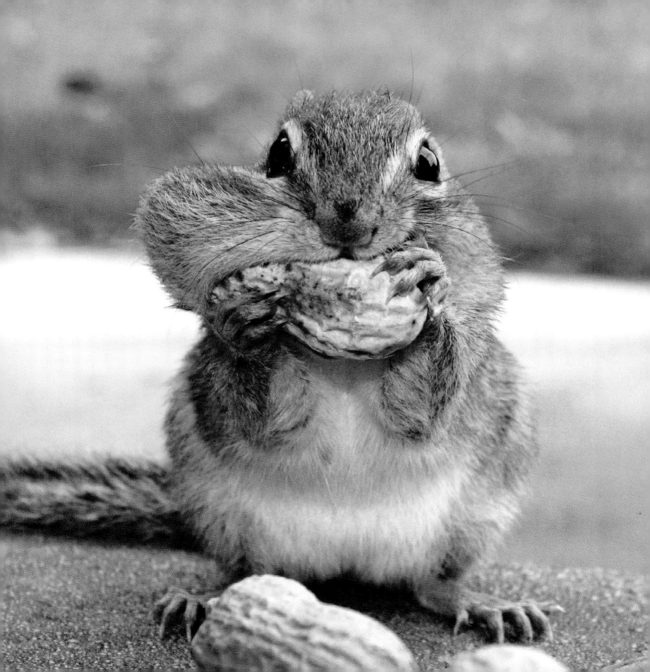

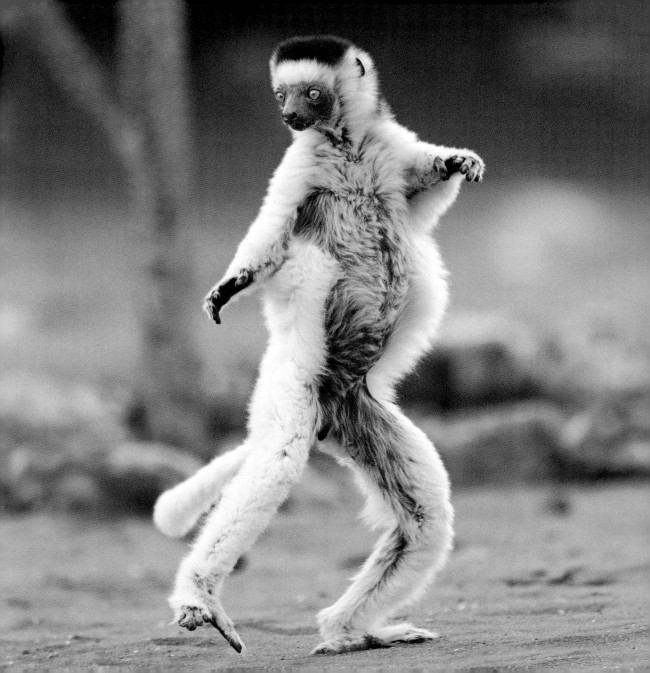

# Love you, Dad,
# for showing me how to
# **dance to my own tune.**

In a group of Verreaux's sifakas *(Propithecus verreauxi)*, chest hair reveals who's on top.
The dominant male's chest fur is dark, while the subordinate males' is light.

# Love you, Dad,
# for telling me when
# the **scary parts** were **over.**

When male sea otters (*Enhydra lutris*) defend their territories, they typically settle disputes with vigorous splashing and "yelling."

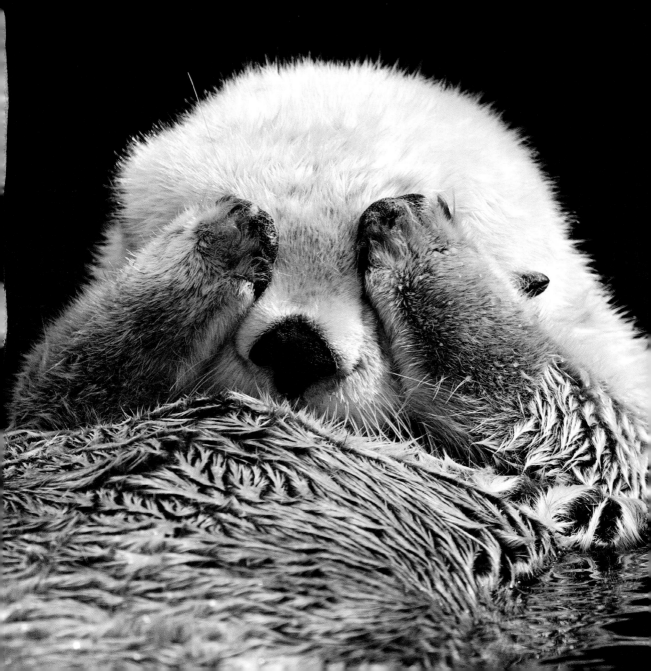

# Love you, Dad.
# You taught me to **dare**
# to **do mighty things.**

A male cat (*Felis catus*) is often referred to as a tom.

# Love you, Dad,
# for being **a rapt audience.**

Male Philippine tarsiers (*Tarsius syrichta*) are usually seen in the company of females, which scientists believe indicates that they are monogamous.

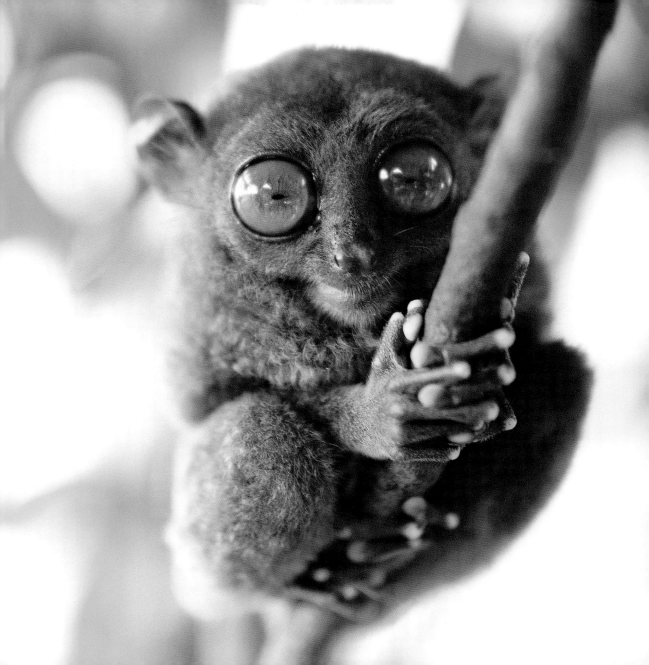

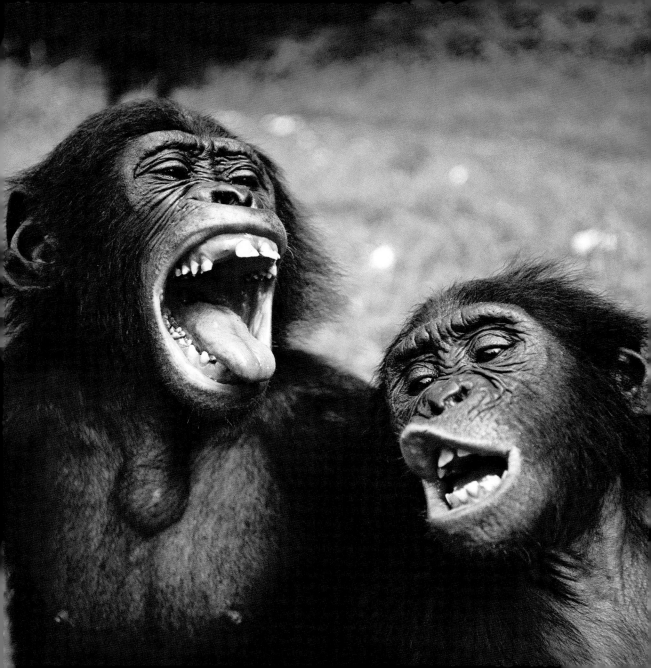

# Love you, Dad,
## for being the
## **life of the party.**

Unlike females, male bonobos (*Pan paniscus*) typically maintain contact with their mothers during adolescence and into their adult lives.

# Love you, Dad,
# for **prioritizing playtime.**

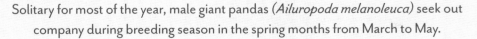

Solitary for most of the year, male giant pandas *(Ailuropoda melanoleuca)* seek out
company during breeding season in the spring months from March to May.

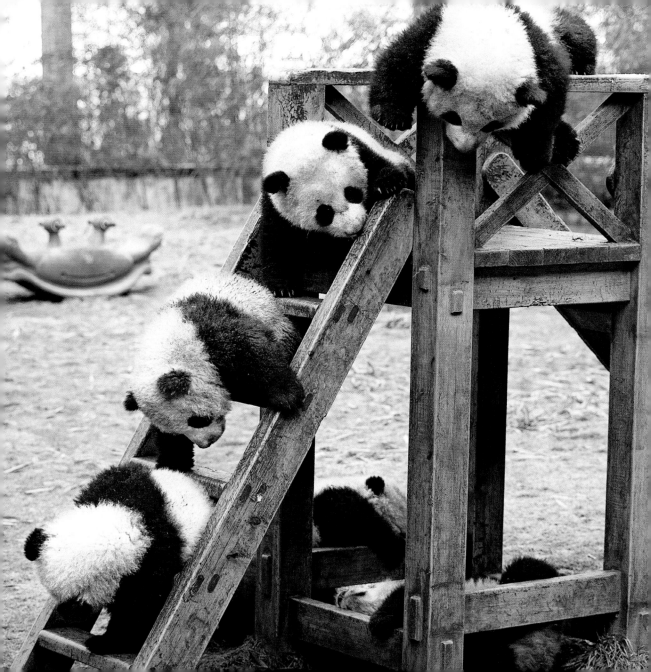

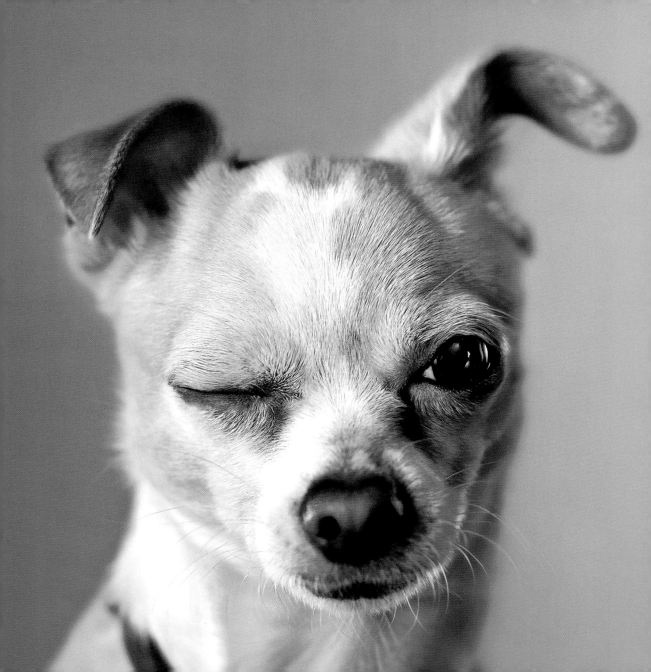

# Love you, Dad,
# for keeping some things
# **just between us.**

Male dogs (*Canis lupus familiaris*) reach puberty anytime between 6 and 12 months of age, but may not be ready to breed until they're older. Typically, the larger the dog, the older he must be before he can become a father.

# Love you, Dad,
## for showing me that
## **practice does pay off.**

A male brown bear *(Ursus arctos)* may reach sexual maturity around five years of age, but he typically won't become a dad until he's reached his full size at about age ten.

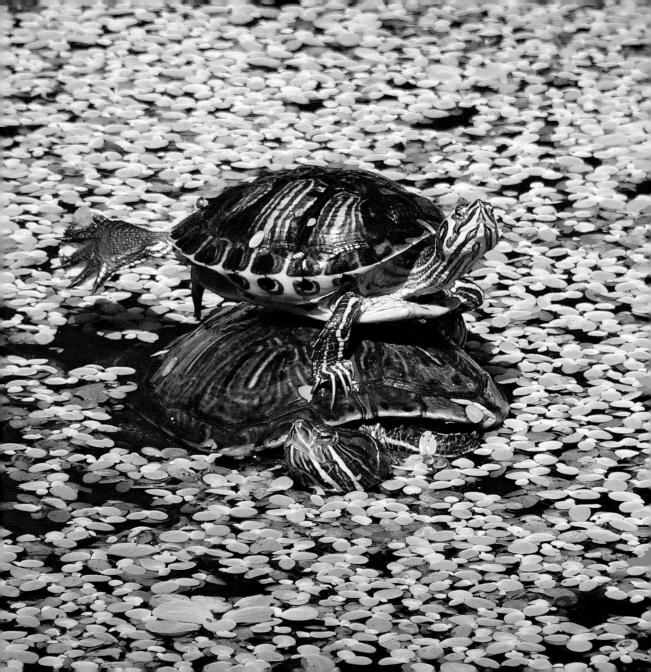

# Love you, Dad,
# for letting me **come out on top**
# once in a while.

During courtship, a male pond slider (*Trachemys scripta*) will swim toward a female,
stretch out his front feet, and then flutter his long claws all over her head and neck.

# Love you, Dad,
## for always giving me
## **a big thumbs-up.**

Dominant male stone crabs (*Menippe mercenaria*) have the biggest claws.

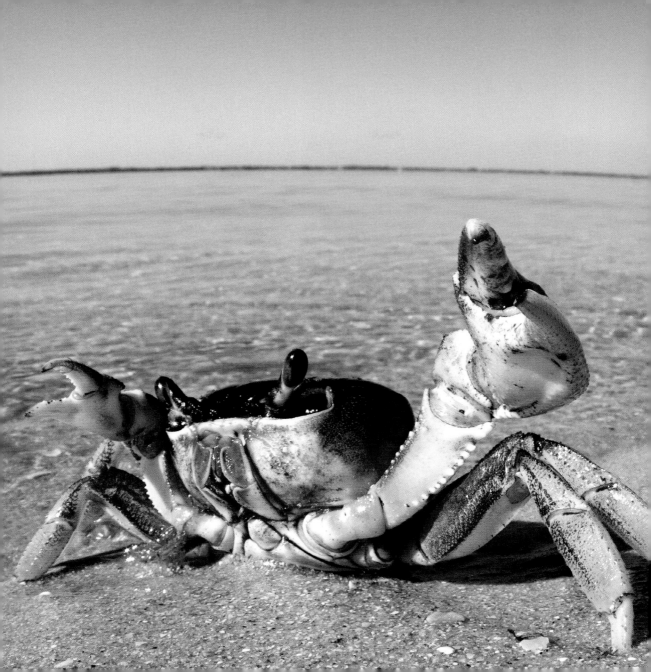

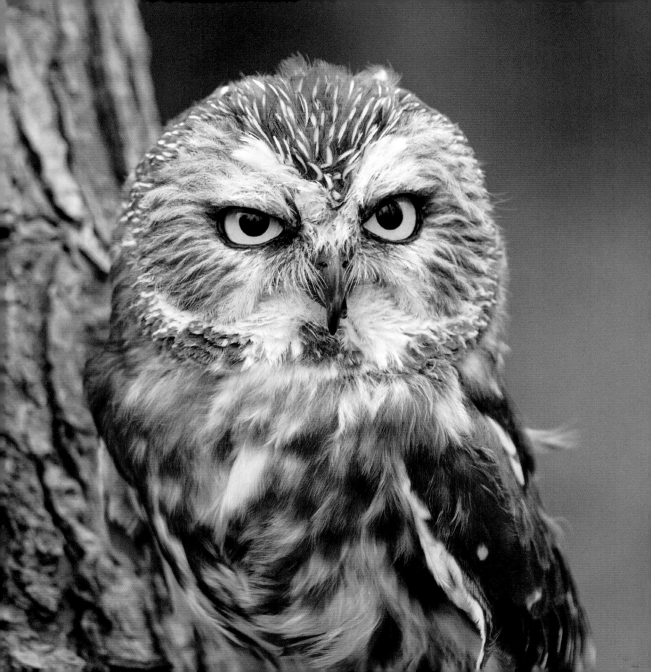

# Love you, Dad.
# Sorry for the times
# **when you were not amused.**

The male northern saw-whet owl (*Aegolius acadicus*) feeds the female while she incubates their eggs. Once the hatched chicks are 18 days old, Mom leaves the nest, and Dad cares for the young birds until they can fly.

# Love you, Dad.
# Thank you **for always being there.**

Male lions *(Panthera leo)* first grow their striking manes,
which vary in color from black to blond, starting at age three.

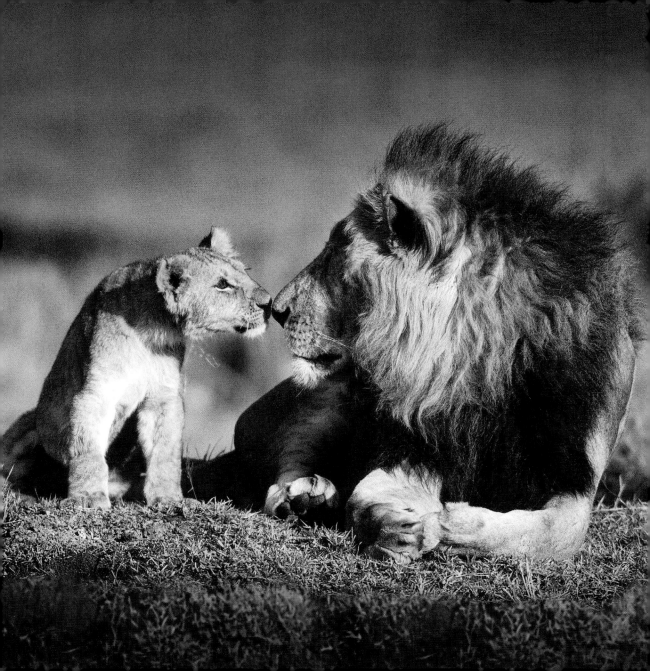

# Illustrations Credits

5, Liliya Kulianionak/Shutterstock; 6-7, Keith Szafranski/iStockphoto .com; 11, Courtesy Melina Gerosa Bellows; 12, Courtesy Melina Gerosa Bellows; 15, Courtesy Melina Gerosa Bellows; 16, Andraž Cerar/Shutterstock; 19, Eric Isselée/Shutterstock; 20, Gerry Ellis/Minden Pictures/ National Geographic Stock; 23, Frans Lanting/National Geographic Stock; 24, Michio Hoshino/Minden Pictures/National Geographic Stock; 27, Sue McDonald/Shutterstock; 28, Perrush/Shutterstock; 31, Lipowski Milan/Shutterstock; 32, intoit/Shutterstock; 35, Johnny Johnson/Animals Animals-Earth Scenes; 36, Sebastian Duda/Shutterstock; 39, Scott Carr/National Geographic My Shot; 40, Roy Toft/National Geographic Stock; 43, Rudy Kellerman/National Geographic My Shot; 44, Mark W. Moffett/National Geographic Stock; 47, Rosie Udovicic/ National Geographic My Shot; 48, Yan Gluzberg/National Geographic My Shot; 51, worldswildlifewonders/Shutterstock; 52, Joel Sartore/ National Geographic Stock; 55, Skip O'Donnell/iStockphoto.com; 56, EcoPrint/Shutterstock; 59, Thomas Marent/Minden Pictures; 60, Anna Jurkovska/Shutterstock; 63, Jim Chambers/National Geographic My Shot; 64, Bianca Lavies/National Geographic Stock; 67, Lori Deiter/ National Geographic My Shot; 68, Hugh Lansdown/Shutterstock; 71, Tom & Pat Leeson/ardea.com; 72, Philip Gould/CORBIS; 75, BlueOrange Studio/Shutterstock; 76, Cyril Ruoso/Minden Pictures/National Geographic Stock; 79, Mitsuaki Iwago/Minden Pictures/National Geographic Stock; 80, Luxe/Shutterstock; 83, Joel Sartore/National Geographic Stock; 84, casinozack/Shutterstock; 87, Danielle Baron/ National Geographic My Shot; 88, Denise Silva/National Geographic My Shot; 91, Morales/age fotostock; 93, WilleeCole/Shutterstock.

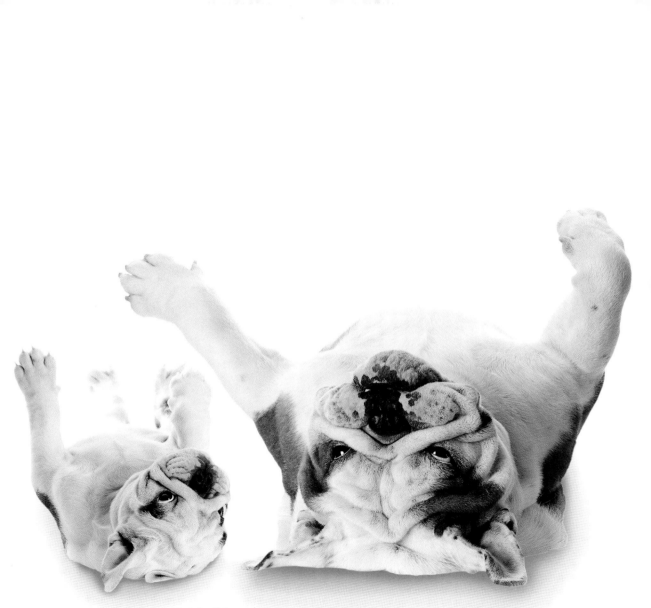

English bulldogs (*Canis lupus familiaris*), father and puppy